Provence, has a thousand faces, a thousand aspects, o...
describe it as a single and indivisible phenomenon.

'.The ardent beams
and the darts of the sun
Kindled in the air a luminous quivering;
And on the plain
The mad little Cymbals
Of the cicadas roasting on the hot grass
Repeated without end their ceaseless clicking.
Not a tree, not a shadow, not a soul!'
MISTRAL - CANTO 8'MIREIO'

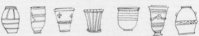

BESSON
ÉTOILE

JARRES FORME ANCIENNE
originally used to store olive-oil.

'One must live here to appreciate
the four colours of figs: the green
with yellow pulp; the white with
red pulp; the black with red
pulp; and the violet, or rather
the mauve, with pink pulp,
and all with such delicate
skin.'
COLETTE - 'Letters from Colette.'

Cicada in full song — 'tssswwssstsssswwtsssw - without a break.' BRANGHAM 'Naturalist's Riviera.'

'Two liquids are particularly beneficial to the human body - internally wine, externally
oil; both are derived from the vegetable world and are excellent, but oil is the
MORE NECESSARY. PLINY the ELDER

'It is better to be bored on one's own than with others.' BONNARD september 1940

'The world does not understand me and I do not understand the world, that is why
I have withdrawn from it.' CEZANNE

'The shadow cast by the olive trees is often
mauve. It is in constant motion, luminous,
full of gaiety and life.' JEAN RENOIR

'my house here is painted the yellow colour of fresh butter on the outside with
glaringly green shutters; it stands in the full sunlight in a square which has a
green garden with plane trees, oleanders and acacias. And it is completely white-
washed inside, and the floor is made of red bricks. And over it there is the intensely
blue sky. In this I can live and breathe, meditate and paint.' VAN GOGH

'It was very soft, very still and pleasant, though I
am not sure it was all once should have
expected of that combination of elements:
an old city wall for a background, a canopy
of olives, and, for a couch, the soil of Provence.'
HENRY JAMES - 'A little Tour in France'

In the summer notwithstanding all the care
and precautions we can take, we are pestered
with incredible swarms of flies, fleas, and
bugs, but the gnats, cousins, are more
intolerable than all the rest. In the day-time
it is impossible to keep the flies out of
your mouth, nostrils, eyes and ears. They
crowd into your milk, tea, chocolate, soup,
wine, and water; they soil your sugar,
contaminate your victuals, and devour
your fruit. SMOLLETT - 'Travels through France & Italy'

'A cat was warming itself in the sun on the
threshold, a cat entirely absorbed in itself
isolated like the house'... HENRI BOSCO 'THE DARK BOUGH'

'A magnificent set of Moustiers
porcelain is placed on the table. Drawn
in blue, on the glaze of each plate, is a
Provençal subject; the whole history of
the land is caught and held in that blue
porcelain.' DAUDET - 'Letters from my windmill.'

'Between ourselves and things
strange affinities exist.' DAUDET

'Against the background of the sky
the white riggings of the sailing
boats criss-cross like pathways.'
COLETTE

'At the exit from a cave were two peach-
trees, still heavy with their loads of fruit.
The picking was not yet over. Under the
finest of the pair a basket made of
reeds and lined with leaves, stood
forgotten. Two peaches only lay upon this
bed, fragrant with honey & dew.' BOSCO.

'Gray hills scented with rosemary.'

'We sigh for the blue of our little Alps and
the wild scent of their lavender.' DAUDET.

SARA MIDDA'S
SOUTH OF FRANCE

—

A SKETCH BOOK

WORKMAN PUBLISHING
NEW YORK

Published simultaneously in Canada by Thomas Allen & Son Ltd.

Library of Congress Cataloging-in-Publication Data

Midda, Sara.

Sara Midda's South of France : a sketchbook / Sara Midda.

ISBN 0-89480-763-3. p. cm.

1. Midda, Sara -- Notebooks, sketchbooks, etc . 2. Riviera in art

I . Title .

ND 1942. M5A4 1990 90-50369

759.2 -- dc20 CIP

ISBN 0-89480-763-3

Workman Publishing Company
708 Broadway
New York, NY 10003

Printed in Japan.
First printing October 1990

10 9 8 7 6 5 4 3 2 1

For
S·J·M·D

CONTENTS

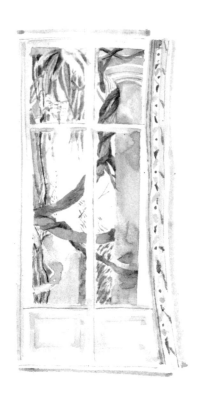

- 4th April 1854 : Death of Hippolyte Allibert de Berthier, botanist from Marseilles, known for his work on the geranium.
- Asparagus season starts.
- April 1764 : Smollett writes, "Beginning April, mulberry leaves begin to put forth; the eggs or grains that produce the silk-worm are hatched.
- Orange trees in flower.
- 5th April 1732 : Nicolas Fragonard is born in Grasse.
- First mosquitoes — beware!
- 6th April 1327 : In the church of Sainte Claire in Avignon, Petrarch meets Laura de Noves, wife of Hughes de Sade. This is the love that keeps him "Anni vent uno ardendo" (aflame for 21 years) until she dies from the Black Death on 6th April 1348.
- Sow first basil seeds in the open.
- 9th April 1858 : Cézanne writes to Emile Zola from Aix : "The weather is foggy, gloomy and rainy, and the pale sun in the skies no longer dazzles our eyes with its opal & ruby flames."
- Fresh anchovies begin to swarm.
- April 1936 : Colette writes in Saint-Tropez, "It's pouring wisteria blossoms and drops of rain".
- April 1696 : The death of the letter writer Mme. de Sévigné, at Grignan
- Cistus in full flower — pink, white, purple flowers — heady scent.
- "Pour Pâques, mangeons de l'oeuf avec un gigot de boeuf de la salade sauvage."
- 26th April 1336 : Petrarch, as he leaves Malaucène with his brother, notes that the first man to climb Mont Ventoux wasn't a professional climber but a poet.
- 27th April 1840 : The death of Niccolò Paganini at Nice.
- Wild mushrooms (morels) to be found.
- 28th April 1886 : Paul Cézanne marries Hortense Fiquet in Aix.
- Pick young broad beans — eat raw with salt, saucisson, olives and bread.
- Lunch sitting on marble slab seat beside a dry stone wall; cold mussels and potatoes mixed with rouille, fennel leaves and raw onions.

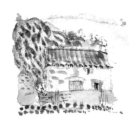

'Portes - fenêtres'
Green, peeling shutters.
Foliage
Apricot coloured walls.

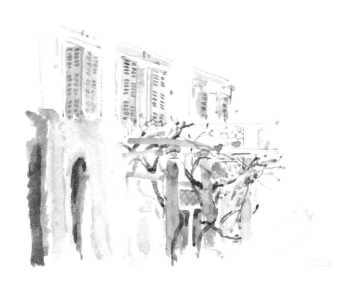

It's strange how housss haunt.

Terraced hillside. Early evening.
Grass covered
Curved dry stone walls - steps cut into them
Paths. Figure appears - disappears
Laden donkey.
Chickens
Running water.
Bird song
Someone digging.
Rows of artichokes and onions.
Rabbit hutches
Bundles of Cannes-de-Provence.
 Log piles. Abandoned car

mimosa tree
orange tree

Houses perched at varying angles.
Wood planked shutters - peeling.
'Tonnelle' - (arbour) - vine covered - to eat under.

Different colours
 Ochres Bauxite - (found in nearby hills.)
Silver greens - mineral rich shades.)
Cerulean blues .
Roses.
Alizarin reds. colours of the earth,
Yellows. plants, sky .

Cobalt blue house
Isolated patch of
 colour.

steps

dry stone wall

open oven
covered for
eating under

table

chairs.

interplanted with violets and early vegetables .

outdoor Kitchen

basin.

washing line between olive trees

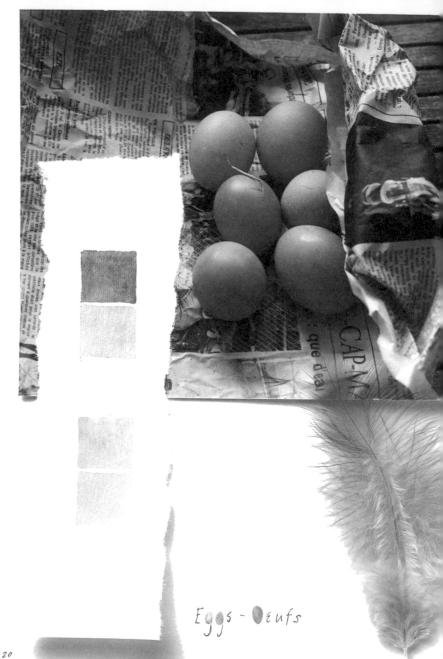

Eggs - Œufs

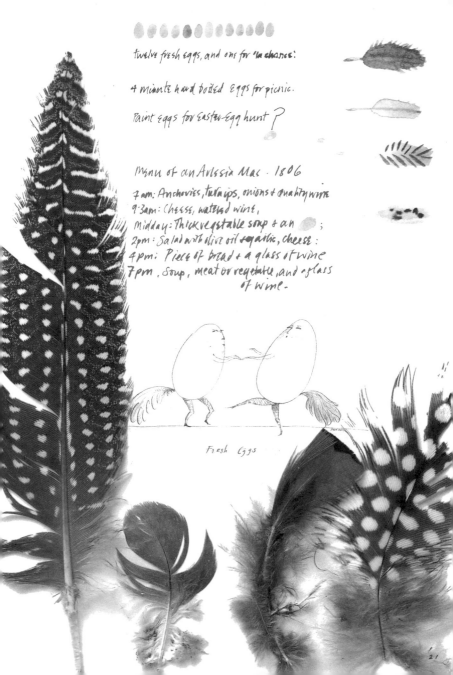

twelve fresh eggs, and one for 'in chance'.

4 minute hard boiled Eggs for picnic.

Paint eggs for Easter-Egg hunt ?

Menu of an Artisan Mac · 1806
7am: Anchovies, turnips, onions & country wine
9·3am: Cheese, watered wine.
Midday: Thick vegetable soup & an ;
2pm: Salad with olive oil & garlic, cheese :
4pm: Piece of bread + a glass of wine
7pm, Soup, meat or vegetable, and a glass
 of wine.

Fresh Eggs

21

- "Le 1er Mai", when it is the custom to give a bunch of muguets (lilies of the valley), and for boys to give girls rosemary as a symbol of love.
- Get out espadrilles.
- 1st May 1247: In Arles Saint-Trophime forbids human sacrifices.
- Olive trees in flower.
- 4th May 1949: Maurice Maeterlinck, author of 'The Life of the Bee', disappears from Nice.
- Tobias Smollett: "From the month of May, till the beginning of October, the heat is so violent that you cannot stir abroad after six in the morning till eight at night."
- 5th May 1838: M. Stendhal oublie son parapluie à l'Hôtel du Nord, Arles.
- 8th May 1868: Lord Brougham, who discovered Cannes, dies there. He is credited with introducing palm trees to the south of France.
- First irrigation of the garden this year.
- Mid May 1955: Graham Sutherland takes possessions of Temps à Pailla, the house he renames Villa Blanche. It had been designed by Eileen Gray in the hills near Castellar; she lived there until the 2nd World War.
- Loquat - first fruit of summer.
- Pentecost "Formerly at Saint-Sauveur-d'Aix, on the day of Pentecost, an artificial dove was thrown from the window of the large portal and flew to the high-altar where she lit the candles in memory of the descent of the Holy-Spirit" - Mistral. On this day one makes a dovecote sweet, with a base of almond paste in which is placed a bean in the shape of a dove. Who finds it will soon marry.
- Picnic in the hills. Gather many varieties of wild pea flowers (lathyrus).
- 21st May 1854: At Château de Font-Ségugne, the Félibrige movement (a group of writers dedicated to preserving Provençal language and culture) is launched.
- Cherry trees laden with fruit.
- In the market - cans filled with sweet-peas and gypsophila. Paniers of strawberries. Young artichokes. Vegetable and herb seedlings.

sardines salées

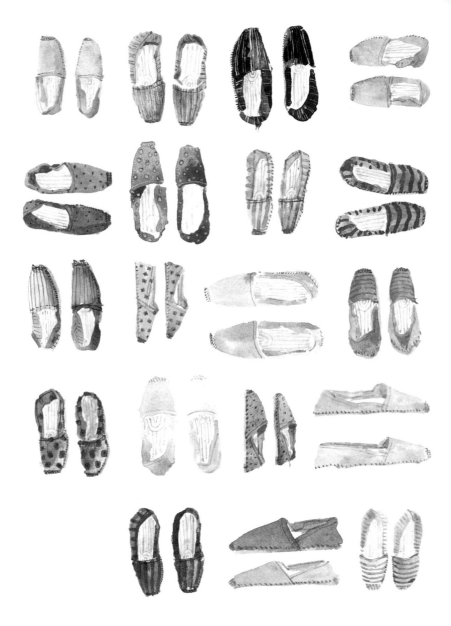

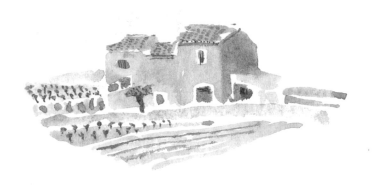

Bank of marjoram - in flower.
Dandelions ?
Salad burnet
Alium (flower)
Wonderful scented Broom
Fennel - young shoots.
Scabious
Drifts of poppies that bleed into the vineyard
Piercing blue flax / linum.
Lathyrus
Spurge
Tiny snails clinging to grass
Convolvulus - thinly striped petals
Small wild gladioli
Santolina - gray/green stems. Faded yellow flowers.
Cistus - (pungent scent always reminds me of leek)
White Roses
Fig trees - small ones

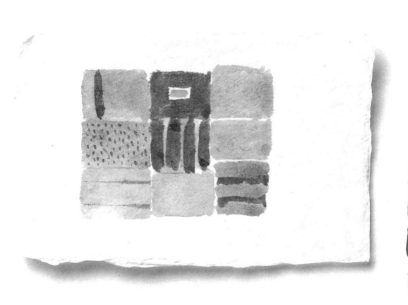

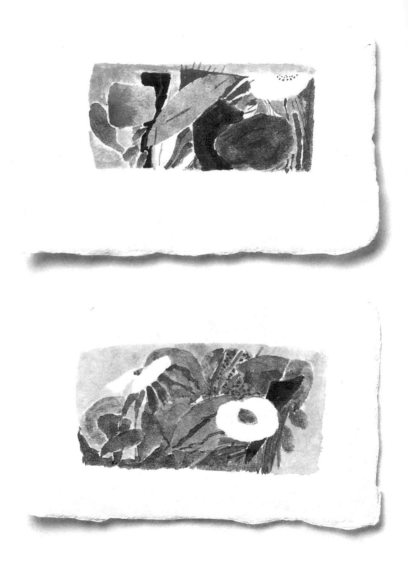

Garden at S.

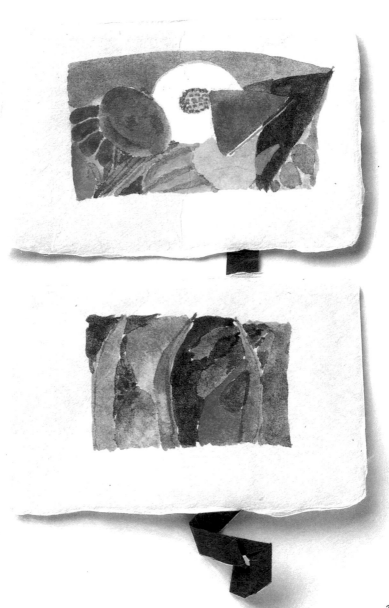

Two varieties of courgettes -

① Courge longue Pleins de Naples which becomes - courge longue

② Round courgettes .

Courgette flower for "les beignets"

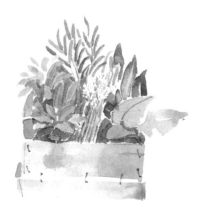

fresh herbs

MESCLUM de PROVENCE

MODE DE CULTURE

Ce mélange est à semer de février à septembre. Les jeunes plantes d'un mois et demi à deux mois, coupés et assaisonnés ensemble vous donneront le délicieux MESCLUM.

Cette pochette contient :
ROQUETTE CULTIVÉE . LAITUE A COUPER FEUILLE DE CHÊNE . CHICORÉE FRISÉE. CHICORÉE SAUVAGE. LAITUE ROMAINE BLONDE MARAÎCHÈRE. CHICORÉE DE TREVISE .

MESCLUM/MESCLUN how sale a mediterranean typically consists of 5 or 6 young salad leaves.

courgettes round courgettes long

31

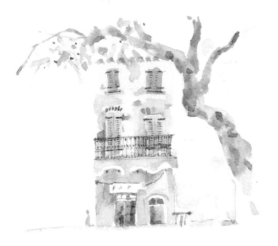

Two men at a green iron
table. Talk of galoubet
and tambour (flute with
3 holes and drum)
Small perched village -houses
face onto river over rows of
onions; lines of washing
in walled allotments.

Balconies stacked
with earthenware pots,
olive oil cans, tubs -
filled with geraniums

VINICOLE

Wine from coopérative
vinicole. At Bouchers!
Charcuteries buy slices of
Caillette made from 'la
gorgue et la fois de porc,
'parsley, sage & nutmeg'.
Pain cuit au feu de
bois.
-Picnic in thicket of
wild fennel

Cabanon built into 'restanque'
-am filled with peculiar sense of possession.

Chapel of
Nôtre Dame de Benva-
(corruption of Provençal 'Benvai
good journey) Stars on the
ceiling. Chapel at Château
de D. – typical open
iron belfry.

Early evening. Playing B●ULES (Pétanque)

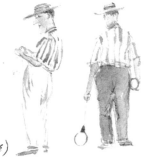

← COCHONNET

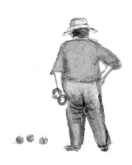

- Appearance of mosquitoes and tourists
- 3rd June 1825. In Provence from this day letters are delivered to people's homes.
- Ant invasion in Kitchen (continuous)
- Take first night-time swim.
- 13th June. 1923: A sturgeon weighing 28 Kilos is caught in the Rhône near Avignon.
- Flowers from Citrus bigaradia (bitter fruited orange) are taken to perfume factories.
- 14th June 1950: Paul Eluard and Dominique Laure marry in Saint Tropez. His second marriage, two years before he dies.
- Mosquitoes abound - all 39 varieties, it seems. Garlic may keep them (and all else) away.
- 15th June: Festival of cherries at Mérindol.
- Emergence of sun hats, panamas and straw hats.
- 18th June 1863: Alphonse Daudet publishes "Chapatin, le tueur de Lions" the first draft of Tartarin de Tarascon.
- First siesta.
- Bougainvillea flowering - purple, magenta or orange against apricot stuccoed walls.
- 24th June: Midsummer Night - the night of Saint John, patron of the harvest; harvesters dance the farandole around log fire. It's a solar festival and children jump over fire to symbolise sun's return.
- Cicadas now in full song.
- 29th June 1886: Monticelli, the Provençal painter, dies.
- Harvest of damask and musk roses for perfume factories.
- June 1922: American troops introduce the Colorado beetle, which ravages potato crops into Provence.
- Transhumance (seasonal migration) of sheep, which are taken to alpine pastures.
- Vengeance — a squashed mosquito.
- Picnic in the hills. Bathe in a spring.
- Serious game of 'boules' - late into the evening.

le restaurant

la famille nombreuse

la belle de nuit

BEST TIMES OF DAY

EARLY MORNING

EARLY EVENING

21 22 23 24 1 2
20 3
19 4
18 5
17 6
16 7
15 8
14 9
13 12 11 10

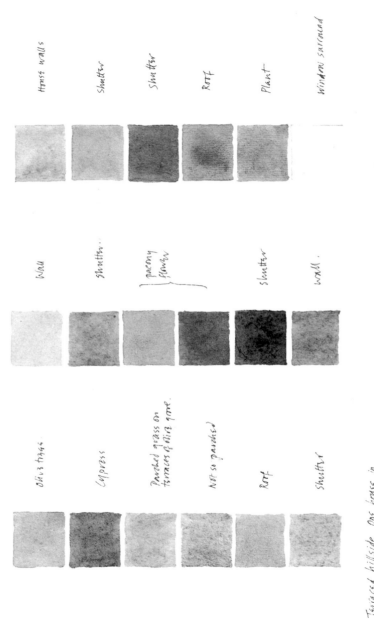

House walls

Shutter

Shutter

Roof

Plant

Window surround

Another house

Wall

Shutter

peony flower

Shutter

wall..

House

Olive trees

Cypress

Parched grass on terraces of olive grove.

Not so parched

Roof

Shutter

Terraced hillside. One house in the olive grove. Cypress trees.

Shutters

Roof

White House

Variegated Ivy.

Plant

Palm trunk.

House

Frieze colors + white

Shutters

Painted ceiling.

House — decorated

One more house.

Terrasses d'oliviers.

Une petite maisonnette des champs.

une remise une ligne d'amandiers

Le domaine

une petite ferme

le cabanon

la cabane

Le petit mas des cigales

façade ombragée par un olivier

une tonnelle
servant de salle à manger

uns bavaree isolée

une bastide

Sun 51

41

Olives

Figs

oxalis

succulent

'old Biot Jarr'.

- 1st July 1876 : Cézanne suffers sunstroke sitting in front of his easel at L'Estaque.
- Early morning and evening swims (avoid being seen).
- 4th July 1655 : The authentic recipe for "Le saucisson d'Arles" is drawn up by the butcher Godart.
- Cicadas in full voice.
- Pick first Amaryllis belladonna (pink flowered variety).
- 1st Wednesday in July: "Foire des Tilleuls" (principal European lime blossom market) is held at Buis-les-Baronnies.
- July 1929 to September, Zelda + Scott Fitzgerald rent Villa Fleur des Bois in Cannes. He is working 'night and day' on a novel.
- Glut of Charentais melons in market.
- 7th July 1973 : Chagall opens the Musée National Message Biblique in Nice on his 86th birthday.
- Lavender in full flower - ready for cutting.
- Vanilla bush scents the garden at night.
- 14th July. Bastille Day. Fireworks and music late into the night in town square; young and old dancing under plane trees to accordion music.
- Dramatic sunsets. Masses of stars
- First cobaea scandens flower appears.
- 20th July 1804 : A column dedicated to Petrarch is erected at Fontaine-de-Vaucluse.
- Sliced peaches sprinkled with sugar, lemon and muscat dessert wine of Provence.
- 21st July 1422 : From this day on the Monks of Saint-Victor-de-Marseille have the right to eat cucumbers.
- This month is prodigal in fruits and vegetables : apricots, peaches, nèfles, haricots verts, garlic, tomatoes and peppers.
- 22nd July : Fête of Sainte-Madeleine dedicated to the brotherhood of gardeners.
- From now until October the Jasminum grandiflorum (jasmine) is in flower; used in the manufacture of perfumes.
- Porphyry cliffs (a beautiful hard rock composed of red or white feldspar crystals) sparkle against the sea.
- Herbs thick on the hills - thyme, rosemary, fennel, savory, sweet bay, sage; they flavour the meat of grazing animals.
- Agapanthus flower on desk.

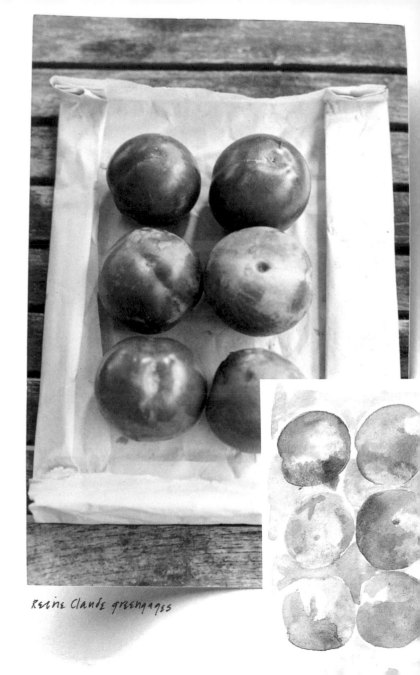

Reine Claude greengages

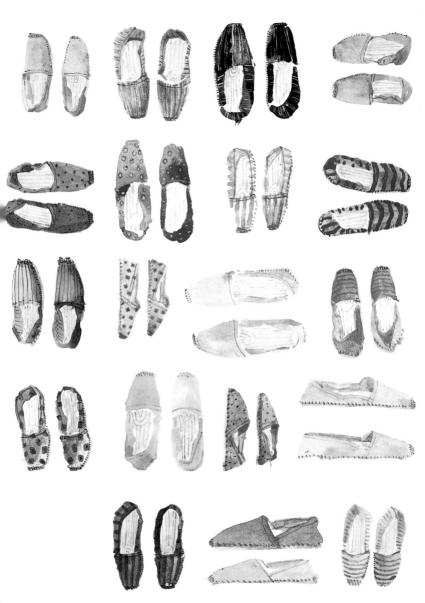

SARA MIDDA'S SOUTH OF FRANCE — A SKETCHBOOK

"Espadrilles" from

SARA MIDDA'S
SOUTH OF FRANCE
A SKETCHBOOK

Available at your
local store

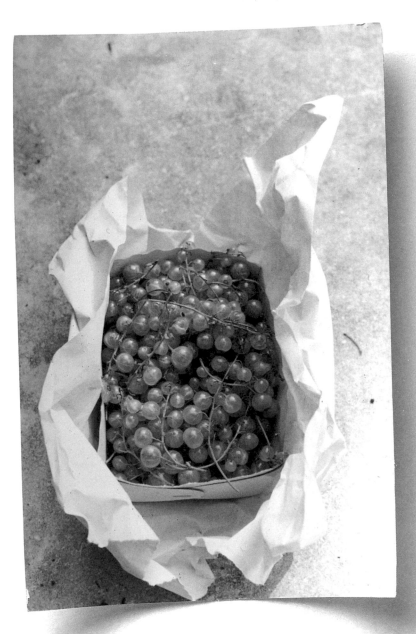

white currants — 51

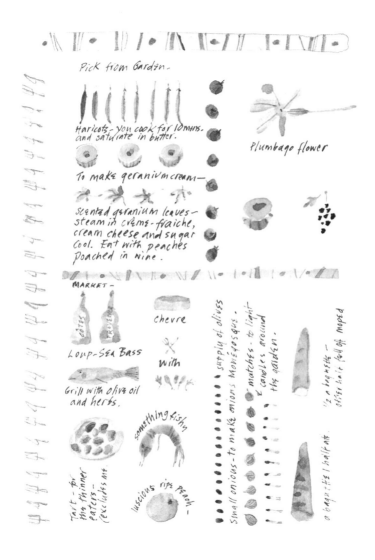

Pick from Garden.

Haricots - you cook for 10 mins.
and saturate in butter.

To make geranium cream —

Scented geranium leaves —
steam in crème-fraîche,
cream cheese and sugar.
Cool. Eat with peaches
poached in wine.

Plumbago flower

MARKET —

CÔTES
PROVENCE

Loup-Sea Bass

Grill with olive oil
and herbs.

chevre

with

Tart — for
the Thinner
paters -
(excluded's me

something fishy

luscious ripe peach —

small onions - to make onions Monègasques.

supply of olives

matches - to light
& candles around
the garden.

1/2 a baguette —
other half fell off moped

a baguette & half eat.

53

PRICKLY PEAR

FIGS

APRICOTS

CHERRIES

ALMOND

CHARENTE
MELONS

GRAPES

PASSION FRUIT

AVOCADO

PERSIMMON · KAKI · KAKI · PERSIMMON

REINE · CLAUDE

GREENGAGES

TREE
STRAWBERRY

PLUMS · PLUM · PLUMS · PLUM

PEACHES
NECTARINES

LEMON

- Lunch - salade niçoise under vine-covered trellis.
- 2nd August 1565: Earthquake in Avignon.
- Myrtilles gathered from the hills.
- 8th August 1818: Joseph Roumanille (a founder member of Félibrigés) is born in Saint-Rémy.
- Aïoli monstre celebration in the village.
- Red flag — jellyfish invasion.
- Fields of sunflowers — Les tournesols.
- The scent of geranium oil (made from the leaves) is like that of roses. Pelargonium capitatum, widely grown for this purpose is harvested at midday.
- Oleander lines the roads - almost at the end of flowering.
- August 1955: Shortly before he dies Léger buys property at Biot. After his death his widow builds a museum here to display his work.
- 2'00 pm - so hot. Heat exhausts and envelops.
- Tables of restaurant laid by the fountain with blue, white and yellow striped cloths. Huge jars of gladiolii stands in the water.
- Fruit of prickly pear (opuntia) ripens.
- Lots of basil - make pesto.
- Prepare cornichons.
- Parties ratatouille in market - aubergine; onion; courgettes; peppers.
- 23rd August 1940: Marshal Pétain forbids pastis to be consumed.
- Pourpier (purslane) grows wild in garden. Delicious in salad-Bourtoulaigo- mixed with other greens, olives and dressing.
- 27th August 1965: Le Corbusier drowns off Roquebrune-Cap-Martin.
- Open-air concert by candlelight in the square by the church.
- Dog takes refuge from heat in the old washing trough.
- In the market - huge pots of bush basil. Street musicians.
- Make scented geranium cream- Leaves steamed in cream, cream-cheese and sugar. When cool- eat with berries or poached peaches.
- Picnic under olive tree, on terraced hillside. Geckos dart from cracks in dry stone wall. From the grass come - ants, beetles and green leaf hoppers!

LOQUATS
LOQUATS

POMEGRANATE

ORANGES

TANGERINE

55

Picnic — Cove west of the water - shute
Facing south Seaward.
Time — 9 p.m.

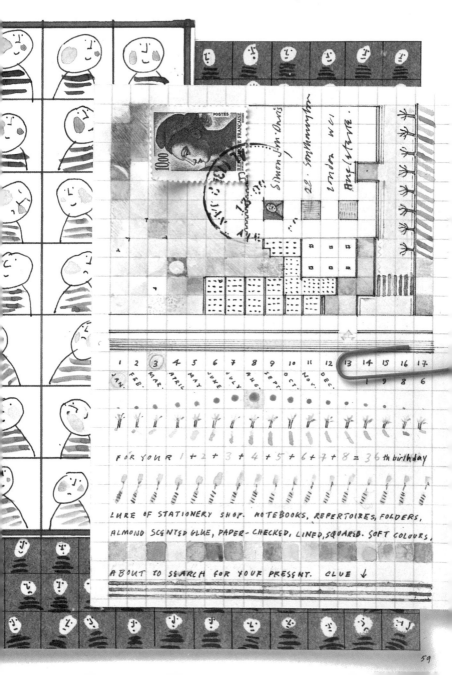

POSTES
1000
RÉPUBLIQUE FRANÇAISE

Simon Jim-Davis
22 Southampton
London WCI
Angleterre.

| 1 | 2 | ③ | 4 | 5 | 6 | 7 | 8 | 9 | 10 | 11 | 12 | 13 | 14 | 15 | 16 | 17 |
| JAN. | FEB. | MAR. | APRIL | MAY | JUNE | JULY | AUG. | SEPT. | OCT. | NOV. | DEC. | | | | | |

1 9 8 6

FOR YOUR 1 + 2 + 3 + 4 + 5 + 6 + 7 + 8 = 36 th birthday

LURE OF STATIONERY SHOP. NOTEBOOKS, REPERTOIRES, FOLDERS,
ALMOND SCENTED GLUE, PAPER-CHECKED, LINED, SQUARED. SOFT COLOURS.

ABOUT TO SEARCH FOR YOUR PRESENT. CLUE ↓

endless search

siesta

must be wondering

enfin ...

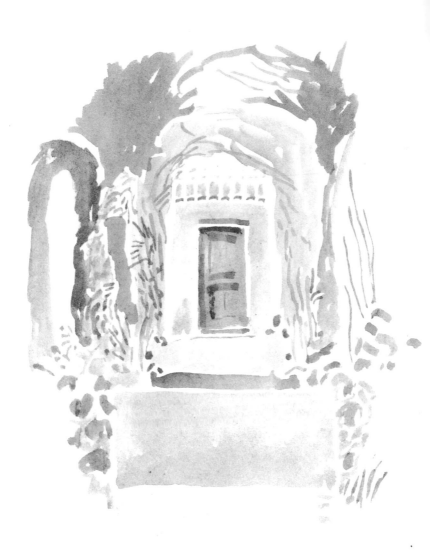

- Dragged to beach for last swimming days of the year.
- 8th September 1830: Frédéric Mistral is born at Mas dòu Juge in Maillane (named from month of May- Maiano - in Provençal).
- 'Vendage'- grape harvest - begins.
- Joined by elderly man in market café who orders wine and lemonade mix. Lesson on regional food; shares a babajuan; explains it is "un délice de manger à la campagne"; how if the paysage is beautiful but cuisine is beastly that is no way to recall a place.
- 13th September 1920: Katherine Mansfield takes up residence in Menton.
- Early morning - Blue ipomoea (morning glory) in flower - covers the walls, trailing on strings 30 feet high.
- 14th September 1927: Isadora Duncan dies in Nice - strangled when her scarf becomes caught in the wheel of car in which she is passenger.
- Make fig jam. Figs, wine and olives = Provence.
- 15th September: "La rentrée"- traditional day for the return to school.
- Good time for haricots (beans) - cook and smother in butter.
- Gathering in of almonds (introduced to Provence in 1548).
- Omelette - making demonstration in market.
- Kakis (persimmons) ripe on their leaves in a flat basket, ready to burst open.
- Pale mauve hibiscus flower against ochre walls and grey shutters.
- Pepper tree (schinusmolle) still producing small red fruit.
- Fat cat asleep on table covered with red and white check 'toile - cirée' in front of door hung with beaded curtain 'rideau de buis' to keep flies out.

onion, lettuce, pepper, aubergine, haricots, tomatoe, melon, chicory, radish, artichokes.

Hill and sky merging.
Isolated house (ochre.)
Terraces
Olive groves
Cypresses
Almond trees.
Rows of vines
vegetables.

Terra-cotta canal tiles.
Double génoise roof supports -
(recessed rows of tiles.)

Shadows on stucco

Plane trees - shade the
road in strips.

CAFE COU

Brasserie

BAR

Gᴰ CAFÉ

Lou Souleù

CAFE

Cafe de L'Univer

de la PAIX

70

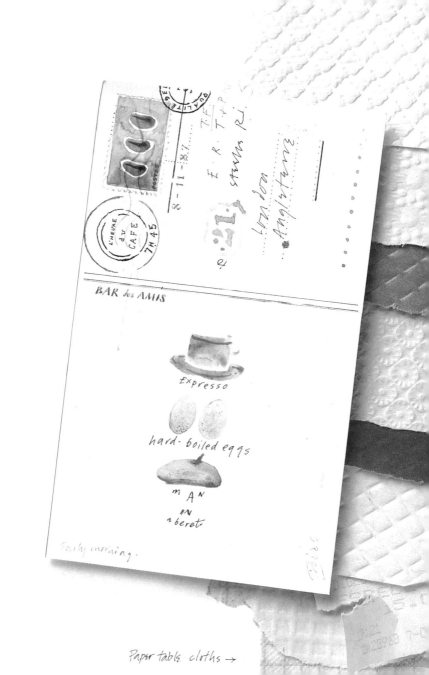

POSTES

8 - 11 - 88.7

T. F.
T. + P.
St.Hilas Rd.

London
Angleterre

to

L'HEURE
du
CAFE
7H45

BAR des AMIS

Expresso

hard-boiled eggs

m A N
in
a beret

early morning.

Paper table cloths →

LE 🏠 MARCHÉ

7am—Croissant aux amandes. Espresso.

Old ladies—grey hair in tight buns.
 blue flowered smocks
 black socks/stockings. Espadrilles.

· Man devouring tartine
· Plump, sunburnt woman—underclothed
· Clochard—pushing trolley of quilts and coats
· Cart piled with wooden vegetable boxes.
Man on bicycle, child clinging, baguettes—precarious
Piaggio vans—grasshopper shaped.
Box on rubber wheels—filled with zinnias—7 francs la botte.
Van that folds down into corset shop—
 Rails of inflated, assorted underwear
 Black, red, white, flesh coloured.

Au bon Semeur—seed packets in racks
 Sacks of seeds.
 Weighed in brown envelopes.

Bowl of eggs—1 franc pièce.
Basket of chickens. Cage of ducks—
2 pintade, trussed, on sack
 Wooden box—three rabbits

Butcher—blue shirt, white overall

Fishmonger—in plastic

Radishes—'Crimson French breakfast'
tied with green raffia.
Raspberries—12f. le carton
Artichoke flowers—5f. la tige.

Pain de campagne—round, crusty.
Saucissons, hams, saucisson pur porc sérac
 saucisson de montagne
On a wooden box—single clutch of eschalotes roses
 Parsley tied with straw. One braid of garlic.

Fill panier with own selection of fennel, aubergines, artichokes
Orange plastic buckets—filled with marigolds.
Olive cans filled with corn-flowers.
2cv car boot raised—inside—a sheep, and owner in peaked cap.

12·15—wooden trestles dis·sembled.
Market washed down. L U N C H

Men's 'bleu de travail'
■ slippers—checked
■ Mouchoirs—checked
■ Napkins—checked
■ Rolls of cotton, polyester,
 floral prints or check

La Quincaillerie—
coffee bowls—blue checked
Opinel folding knives.
Saucepans.
metal coffee pots.
string-bags
Cream coloured china

mushrooms. champign
cèpes secs. sanguins
cèpes noirs
Girolles. Pleurots.

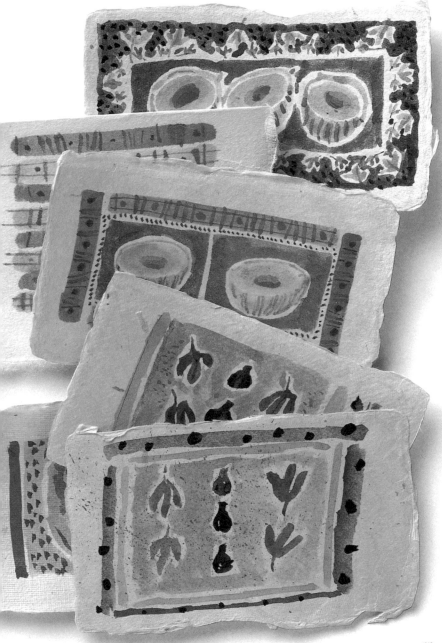

Cheese stall
Fromage pur chevre.

wooden chip box
of butter

chabicou

BANON
gold
paper
hat

PICODON

BANON
Tied up with leaves

Greenish yellow
FERMIERS

PUR CHEVRE
—white +
green
mould

Chevre Fermier

Buchetts pur
chevre

FROMAGE PUR CHEVRE
CROTTIN
crème colar

CHEVRE SEC

CHEVRE
white

Chevre Claperedes

CROTTIN de Chavignol

yellow

chevre with Basil

PUR BREBIS
BASQUS
e sheep
Hard
crusty
brown

FRAISES DES
Panier Ratatouille
FINES
Radis

Ail. Eschalottes

COURGETTE FLOWERS
GYPSOPHILIA
OLIVE OIL
ESCARGOTS

BOUDINS
SALAMIS
SAUCISSE
CHEVRE DU PAYS
PURE CHEVRE
PICODON

MORUE SÈCHE
42 Foo
S.t.n
soupe

Nectarines
Très sucré

AU NECESSAIRE
Assortiment
d'Articles
de Menage

Haricots
verts
citrons

NAVET
ROCARDO
CAROTTE
RADIS/LONG
FLAMBOYANT
BATAVIA
ROUGE

BOXES OF CORNICHONS.
FIGS WRAPPED IN THEIR LEAF.

1989
R.A.F.

COURGE
Poulet
25 F PIECE

EXHAUSTION

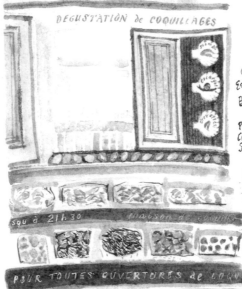

GRAND CAFÉ - DE SID

DÉGUSTATION de COQUILLAGES

squ à 21h30 Maison de coquill

POUR TOUTES OUVERTURES de COQU

Cuisss Grenouilles
Escargots
Bouquet
 Cœuvettes
Pain de Seigle
Crevettes Grisss
Scampi

des Huitres
Spéciales
Vertes de Claires
Fines de Claires
Citrons
Amandes de Mer
Oursins
Biqoinéaux
Palourdes
Tourteaux
Crevsttes
lanaousttes

Maules - Bouziques
Espagne
Bouchot
Super Bouchots

- Early morning - go to the harbour as fishing boats come in. Many good fish this season
- 1953 - Picasso working at Madoura pottery in Vallauris.
- Transhumance at beginning of month; goats and sheep come down from their alpine pastures for the winter.
- October 1970 : Jean Giono dies in Manosque. "Provence has a thousand faces, a thousand characters, and it is false to describe it as a single and individual phenomenon."
- 18th October 1738: Earthquake in Carpentras.
- Time to make green tomato jam.
- After autumn rains, masses of wild mushrooms.
- 18th October 1564: Nostradamus predicts to Henri de Béarn, at Salon, that he will become King of France (Henri IV).
- Gather sweet chestnuts from the woods. (Later find that windfalls are no good - full of maggots).
- 20th October 1888 : Gauguin arrives in Arles to stay with Van Gogh (not an entirely successful visit). (They didn't get on).
- 22nd October 1906 : Cézanne dies in Aix-en-Provence.
- Make moules marinières - use small Bouchot mussels.
- 24th October 1864 : Tsar Alexandre II and Tsarina arrive in Nice.
- 28th October 1846 : Auguste Escoffier, the great chef, is born at Villeneuve-Loubet; he dies after a long career, at Monte Carlo in 1935.
- Pick one of the last datura (angel's trumpet) flowers - it is said a single bloom gives a dangerously heady scent.
- Tibouchina in large green glazed pot, in flower - dense mauve/blue.
- 1763 Autumn : Smollett visits 'Pont du Gard'. "A piece of architecture so unaffectedly elegant, so simple and majestic...". 100 years later Charles Kingsley describes first impression of it in letter to his wife as - "one of simple fear."
- Picnic on old harbour wall. Saucisson, tomatoes, bread and olives tied in blue checked cloth; man in 'bleus' fishing for 'la petite-friture'.

PICNICS - PLACES - WEATHER - SOUNDS

ALPINE PASTURE · OLIVE GROVE · WITH A VIEW · MOUNTAIN TOP · BY THE SEA · OR STREAM · ROADSIDE

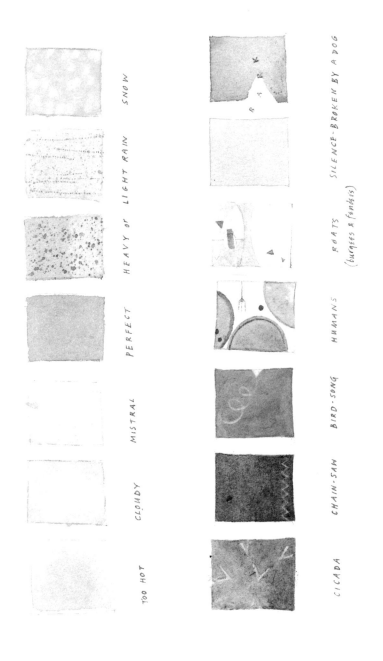

SNOW

HEAVY or LIGHT RAIN

PERFECT

MISTRAL

CLOUDY

TOO HOT

SILENCE - BROKEN BY A DOG

BOATS (burgees & fondys)

HUMANS

BIRD - SONG

CHAIN - SAW

CICADA

charentais melon

Pond - lilies. tadpoles.

OPTIQUE

POMMES de TERRE

GRAINETERIE

Lav'net

BLANCHISSERIE

DROGUERIE
QUINCAILLERIE
articles funèraires

Salon
de COIFFURE

HORLOGERIE

CHAUSSURES la CODASERIE

JEAN STARCK

Shop signs

HERBORISTERIE

ALIMENTATION
JOURNAUX LIBRAI

BEURRE ❖ ŒUFS

BOUC

COUTELLERIE

OURRELLERIE

CADEAU

EPICERIE
J. Fantino

AU GATEAU

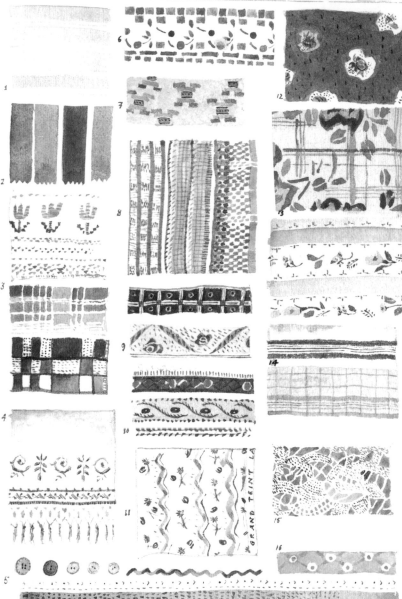

"Linge de maison · tissus d'ameublement · coutils rideaux · articles de literie·

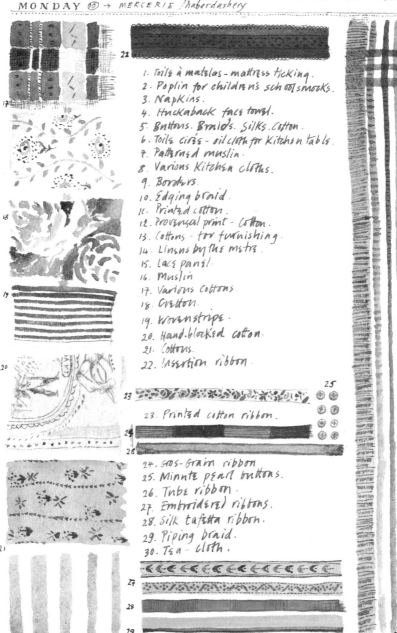

1. Toile à matelas - mattress ticking.
2. Poplin for children's school smocks.
3. Napkins.
4. Huckaback face towel.
5. Buttons. Braids. Silks. Cotton.
6. Toile cirée - oil cloth for kitchen tables.
7. Patterned muslin.
8. Various kitchen cloths.
9. Borders.
10. Edging braid.
11. Printed cotton.
12. Provençal print - Cotton.
13. Cottons - for furnishing.
14. Linens by the metre.
15. Lace panel.
16. Muslin
17. Various Cottons.
18. Cretton.
19. Woven stripe.
20. Hand-blocked cotton.
21. Cottons.
22. Insertion ribbon

23. Printed cotton ribbon.

24. Gros-Grain ribbon
25. Minute pearl buttons.
26. Tube ribbon.
27. Embroidered ribbons.
28. Silk taffeta ribbon.
29. Piping braid.
30. Tea - cloth.

- 1st November : 'La Toussaint' - first day of winter in Provence and day the new year's wines used to be decanted.
- 3rd November 1954 : Henri Matisse dies in Cimiez, Nice.
- Log cutting and splitting. Light first log fire in the evening.
- 15th November 1864 : Alexander Dumas makes a deal with the municipal government of Cavaillon - that in return for giving 194 volumes of his work to the library, he will receive 12 Cavaillon melons annually, for life.
- 16th November 1888 : Henri Bosco born in Avignon. "Beyond the stacks, and rather higher up the hill, on a levelled piece of ground, there stood a cottage. A front wall of red-brown stones, and a quince tree. A well under a fig tree and, in front of the door, the two indispensable cypresses. Some muscat grapes... and that was all. But everything in its own kind, perfection."
- Picnic on edge of vineyard. 'Sarment' - prunings of vines lying on the earth.
- November 1905 to June 1906 - Georges Braque winters at L'Estaque - paints first Fauve paintings.
- 21st November : Gathering olives traditionally begins.
- 22nd November : 'The day to sow beans.'
- 24th November : Truffle market in some villages
- Plane trees begin to be cut back.
- Fruit still on persimmon trees - no leaves - they look as if hung with decorations.
- 1901 November : Paul Cézanne buys some land on a hill near Aix-en-Provence to build house and studio.
- Sunday lunchtime - the sound of cutlery, china & voices.

Greenhouses. Flower growing

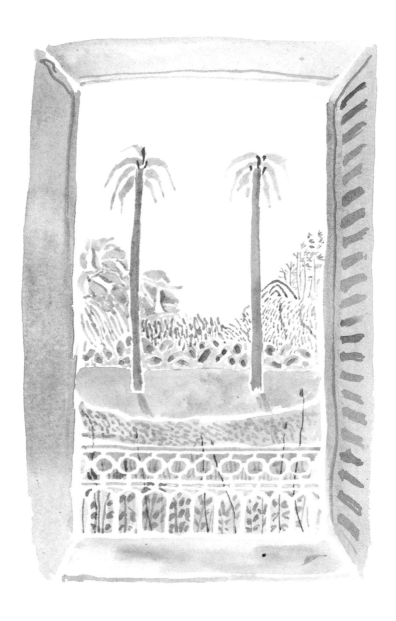

Palm trees line the road, some bullet-holed from the war

Some have clipped hugs of clinging ivies at their base

At times out of control, at times seeming to hold tree upright

On top bird brought treelets spring; roses climb from below

In summer a tree man ascends to trim the dead fronds

They are hessian wrapped or barreled ready for moving

And at Christmas are decked with coloured lights.

Interrupted with wines. Spring vegetables or violets

OLIVIER EN 'HAUT TIGE'

OLIVIER en TABLE

OLIVIER EN BOULE

Shapes of Olive trees.

Lunch - olives, coarse bread, wine.

Olives Niçoises

Olives au Citron
Fenouil

Noires
Façon Grèce

Vertes
Picholines de
Provence

Noires de Nyons

Vertes Cassées
des Baux

Sauce Escabèche

Olives Cassées
aux herbes

Olives aux
Herbes de Provence

Farcies Poivrons

Noires à l'ail
et basilic.

L'AÏOLI

AÏGO BOUIDO	-'Boiled water'- garlic soup, served with oil over slices of bread.
AÏOLI	-Garlic mayonnaise
AÏOLI GARNI	-Grand Aïoli - Aïoli served with boiled food - salt cod, eggs, vegetables.
ALMONDS	
ANCHOÏADE	-Pounded anchovies with oil and vinegar.
APRICOTS	
ARTICHOKES	
ASPARAGUS	-Aspèrges Violettes - short, purple tipped Niçoiss variety. Green variety from Vaucluse, Var and Bouches du Rhône.
AUBERGINES	

BOURRIDE

BAGNA CAUDÀ	-Sauce of anchovies, garlic and olive oil - eaten with raw vegetables.
BANON	-Goat's cheese, dipped in eau-de-vie and wrapped in dried chestnut leaves. Aged for one year.
BARBOUIADO	-Vegetable ragout.
BARIGOULE	-Artichoke hearts, chopped sausage meat, bacon, mushrooms and garlic.
BASIL	
BAY LEAVES	
BEIGNETS DE FLEURS DE COURGETTES - Courgette flower fritters.	
BERLINGOTS	-Caramels - speciality of Carpentras.
BI-VALVES	-Especially in Marseilles area. Praires, Amandes de mer and Clovisses - (types of clams) Moules. Violets.
BLETTE	-Swiss Chard.
BOUILLABAISSE	-Elaborate fish soup. Fish and stock served separately.
BOURRIDE	-Fish soup made of white-fish stock thickened with aïoli and egg yolks.
BRANDADE	-Pounded salt cod, olive oil and garlic.
BREBIS	-Sheep's-milk cheese.
BROAD BEANS	-Early ones- 'fevettes'-eaten raw.

BRANDER-TO CRUSH · SALT-COD-MILK-OLIVE OIL · BRANDADE

CAILLETTE	-Pate- of pork, garlic and herbs.
CALISSONS	-Diamond shaped sweets of ground almonds and candied melon. Speciality of Aix-en-Provence.
CALMARS	-Small squid.
CANDIED FLOWER PETALS.	
CANDIED FRUITS	
CANNELLONI	
CASSE-CROÛTE	-'Breaking the crust'- staves off mid morning hunger.
CÈPE	-Wild mushroom
CHERRIES	
CORNICHONS	-gherkins.
COURGETTES	-
CRYSTALLISED FRUITS.	

TOURTE AUX BLETTES · CHARD

DAUBE À LA NIÇOISE - Stew of beef or lamb, red wine, onions and tomatoes. Cooked in a daubière - earthenware or tinned copper casserole.

DORADE - Mediterranean Sea Bass.

ESCABÈCHE - Provençal dish of small fish, browned in olive oil, marinated in herbs and vinegar. Served cold.

ESTOFICADO - Stew using wind-dried cod (stockfish).

ESTOUFFADE À LA PROVENÇALE - Beef stew cooked with garlic, onions, carrots and zest of an orange.

FARIGOULE - Provençal name for wild thyme.

FENNEL

FIGS

FISH SOUP - Soupe aux Poissons

FOUGASSE - Oil based bread. Lattice-like form. Can be flavoured with olives or herbs.

FROMAGE de CHÈVRE - Goat's-milk cheese. Constitutes majority of Provençal cheeses.

GANSES - Niçois doughnuts

GARLIC - 'Plays an obligatory part in Meridional Cuisine.'

GIROLLES - Wild Mushroom.

GNOCCHI

GRAPE FRUIT

GRAPES

HARICOT - Bean

HERBS - Herbes de Provence Mixed dried herbs.

HONEY - Miel. Miel de laraude - lavender scented honey.

HYSSOP

KAKI - Persimmon

LEMONS

LEMON TART - Tarte de Citron

LIME TREES - Flowers picked and dried in June, for lime tea - 'Tilleul.'

LOU CACHAT - Crushed cheese

LOU PEVRE - Goat's milk cheese, piquant, rolled in coarsely ground black pepper.

OLIVE OIL

MANDARINES
MARC — Grape spirit
MARJORAM
MARRONS GLACÉS — Candied chestnut. Chestnuts often from Marie's forest.
MELON DE CAVAILLON.
MERENDA — Mid morning snack
MESCLUN — Salad of mixed young leaves
MORUE — Salt cod.
MYRTILLES — Bilberry

NÈFLE — Fruit. Japanese name — Biwa.
NONATS — Tiny Mediterranean fish. Deep fry.
NOUGATS — Sweet of roasted almonds, egg whites and honey. May have nuts added. Montélimar is nougat capital of France.

ANCHOVIES

ONIONS

PISSALADIÈRE

OCTOPUS — Poulpe
OLIVE OIL
OLIVES
ONIONS
ONIONS MONÉGASQUE — Small onions, cooked in oil, little tomato, vinegar, sultanas and orange rind.
ORANGES — Sweet bloodied ones. 'sanguines'.
OURSINS — Sea urchins

PIZZA

PALAIA — Small sardines and anchovies — used for Pissala
PAN BAGNAT — 'Wet bread' — Small round bread filled with salad. Niçoise mixture
PANISSES — Deep fried chick pea flour pancake.
PASTIS
PEPPERS
PEACHES
PEARS
PICODON — Small aromatic goat's milk cheese from North Provence.
PISSALA — Fish purée used in Pissaladière.
PISSALADIÈRE — Tart of onions, pissala & black olives.
PISTOU — 'Pounded'. Sauce derived from Italian Pesto — Basil, garlic, pine nuts, olive oil. essential part of soupe au Pistou.
POMEGRANATE —

LA PORCHETTA

POMPE À L'HUILE — or GIBASSIER — sweet flat bread with pieces of lemon rind, flavoured with olive oil.
PORCHETTA — Roasted young pig — stuffed with herbs garlic and offal.
POUTARGUE — Salted dried and pressed roe of grey mullet.
POUTINE — Anchovies and sardines in larval state. Quantities fished are limited.

RADISH	
RAÏTO	- sauce of red wine, onions and tomatoes.
RASCASSE	- Essential fish in bouillabaisse.
RATATOUILLE	- Cooked dish of aubergines, courgettes, onions, peppers, garlic and olive oil.
ROSEMARY	
ROUGET	- Fish.
ROUILLE	- Olive oil, garlic, chili mayonnaise. Float in fish soup.

PURSLANE

SAGE	
SALAD NIÇOISE	- tomatoes, beans, egg, anchovies, tuna, potatoes, black olives, peppers, onions.
SARRIETTE	- Summer savory.
SARTANDO	- Dish of very small fish. Fried in olive oil served with sprinkling of hot vinegar.
SAUCISSONS D'ARLES	- Dried sausage.
SNAILS	- Helix Aperta - collected in Autumn from hills around Nice.
SOCCA	- Thin round pancake of chick-pea flour. Sold from street vendors.
SOUP À L'AIL	- Garlic soup.
SQUID. SOUPIONS	- Small squid or cuttlefish.
STOCKFISH	

LA SOUPE

AU PISTOU

TAPENADE	- Black olives, capers, olive oil, lemon and perhaps anchovies blended together.
TARRAGON	
TARTARINADES	- From Tarascon. Chocolate candies named after Daudet's fictitious character - Tartarin.
THYME	
TOMATOES	- Tomates farcies à la Provençal - cut in half, parsley, olive oil, garlic - grill.
TOURTE AUX BLETTES	- Sweet tart of chard, eggs, cheese, raisins and pine-nuts.
TREVISO CHICORY	- Bitter red salad green.
TRIPE	
TROUCHIA	- omelette filled with chard.
TRUFFLES	- Tubers found on roots of 'White Oak'.
UTENSILS	- Pignata - earthenware casserole, with hollow handle. POÊLON - Provençal name. TIAN - earthenware gratin dish.

LA SOUPE DE

CROUTONS · ROUILLE · FROMAGE

POISSONS

VIN CUIT	- Sweet dessert wine.
VIOLET DE PROVENCE	- Braid of garlic
VIOLETTE	- Crystalised petals of violet.
WINES	- Many
WATERMELON	
WILD BOAR	- berrate.
WILD ASPARAGUS	
WINTER SAVORY	

POIS CHICHE

SOCCA

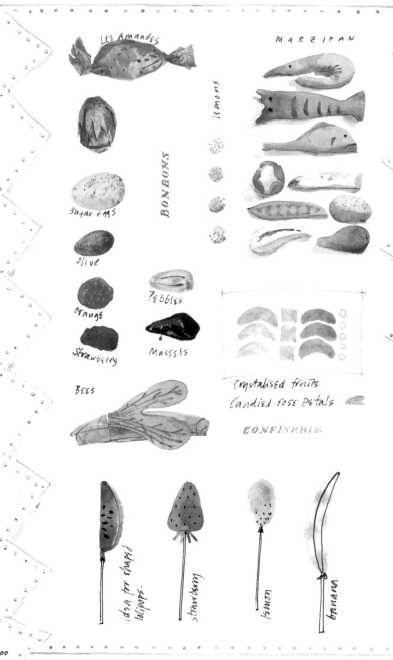

Les Amandes

MARZIPAN

lemons

BONBONS

Sugar eggs

Olive

Pebbles

Orange

Mussels

Strawberry

BEES

Crystalised fruits
Candied rose petals

CONFISERIE

idea for shaped lollipops.

strawberry

lemon

banana

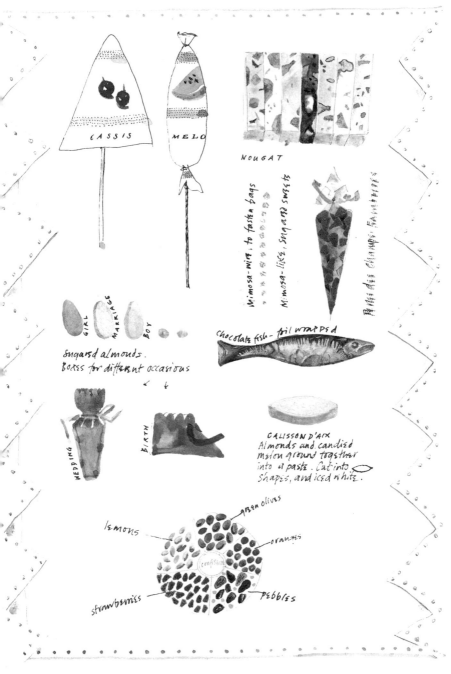

CASSIS

MELO

NOUGAT

Mimosa-wire, to fasten bags

Mimosa-lize, sugared sweets

Petits des Champs: Framboises

GIRL

MARRIAGE

BOY

sugared almonds.
Boxes for different occasions

chocolate fish — foil wrapped

WEDDING

BIRTH

CALISSON D'AIX
Almonds and candied
melon ground together
into a paste. Cut into
shapes, and iced white.

green olives

lemons

oranges

confision

strawberries

pebbles

- Pick first mimosa - grey-leaved species - to fill green jug.
- Time to make olive oil.
- 6th December 1763: Smollett reaches Nice. "When I rose in the morning, I opened a window that looked into the garden, I thought myself either in a dream, or bewitched. All the trees were clothed with snow and all the country covered, at least, a foot thick. 'This cannot be the South of France ...'"
- Toboganning on plastic sacks.
- 8th December 1883: Train with sleeping cars starts running, the Calais-Nice-Rome Express.
- 12th December 1869: Alphonse Daudet publishes 'Tartarin sur Les Alpes'.
- Aloes flowering.
- 14th December 1503: Michel de Nostredame (Nostradamus) is born in Saint - Rémy.
- Annual Santon fair in Marseilles. 'Santons' (little saints) - clay statuettes for Christmas crib.
- Make paper chains.
- Hang tree with foil-wrapped chocolate fish, white paper cutouts, sweets wrapped in printed tissue.
- Learn to open oysters.
- Christmas Eve: Traditional 'gros souper" (no meat) - fish, vegetables, aïoli - followed by 'treize desserts" (13 sweets) - dried grapes, small cakes, almonds, nougats, crystallized fruits, olive oil biscuits made up to the 13 by fresh and dried fruits - accompanied by 'vin cuit' of the area.
- Large water-filled glass bowl on table - goldfish, petals, floating nightlights. Individual containers for each person with: wild strawberry, arbutus, olive branch, rose, paper white, kumquat.

Blue sky

Favourite French Car.

SUCRE
SUGAR
ZUCCHERO
ZUCKER

GÉNÉRALE SUCRIÈRE

SAINT LOUIS PURE
CANNE

Pour lui garder
sa propreté
nous servons ce sucre
enveloppé

5

SAINT LOUIS PURE
CANNE

GÉNÉRALE SUCRIÈRE

SUCRE
SUGAR
ZUCCHERO
ZUCKER

6

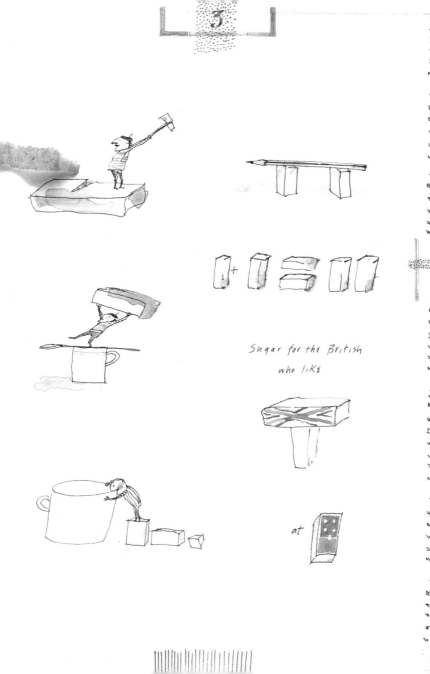

Sugar for the British
who like

at

A QUEST FOR SOMETHING

XXX

DELICIOUS FROM THE

PATISSERIE

Pâtisserie

Glaces-Salon
de Thé

1, Place Clément

J. M. F.

tartes aux Fruits

rte aux fraises

Citron

Dôme chocolat

Baba au ri...

Palmier

Panier

Citron

Al pezzo

surprise au chocolat

Le Voyage

Le Piane-Niane.
Bread . Sancisson
cheese . Butter
olives .
· · · · · · · · · · · ·
Eggs vegetables
2 Figs.
and a bottle of wine.

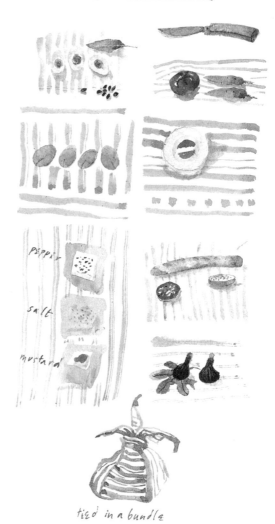

peppir

salt

mustard

tied in a bundle

- New year's Day: Eat lentils to bring riches.
- Truffles are their ripest now and in February.
- 4th January 1960: Albert Camus dies. He is buried at Lourmarin where he spent the last three years of his life.
- 6th January: 'La Fête des Rois' (Twelfth Night). Make a brioche in the form of a crown and decorate with crystallised fruits symbolising precious stones; the person who finds the bean hidden inside it is said to 'tirer le roi.'
- Marmalade making.
- 7th January 1891: The first issue of Mistral's journal L'Aïoli is published.
- Good time to buy fresh olive oil.
- Thomas Hanbury: 'I am disappointed if I have fewer than 450 species of flower in the open border at La Mortola (his garden just over the French-Italian border) in the month of January.'
- Pick 'Soleil d'or' narcissus and the first 'Paperwhite.'
- 15th January 1764: Smollett writes how carnations are sent by post from Nice to Paris or London 'packed up in a wooden box, without any sort of preparation, one pressed upon another; the person who receives them cuts off a little bit of the stalk, and steeps them for two hours in vinegar and water, when they recover their full bloom and beauty.'
- Solid ceaseless rain.
- 17th January: Fête of Saint-Antoine, patron of basketmakers is celebrated at Cadenet in the Vaucluse.
- 19th January 1839: Cézanne is born at Aix-en-Provence 'Drawing and colour are not separate and distinct, as everything in nature has colour.'
- Poutine on sale in the market. Try like whitebait.
- Learn to drive with tyre chains over snow-covered mountains.
- January 1957: Jean Cocteau finishes his decorations in the Romanesque fishing chapel at Villefranche.
- January-February 1888. Monet at Château de la Pinède in Antibes. Paints 36 canvases at this time. Writes to Rodin: 'I'm fencing and wrestling with the sun. And what a sun it is. In order to paint here one would need gold and precious stones.'
- In the market, bundles of dried herbs, 'Paquet Potage' (carrots, leeks, a turnip, celery stalks tied with raffia) and a jar of snowdrops.

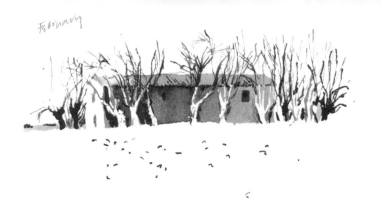

February

Minus 8°
Stream frozen over

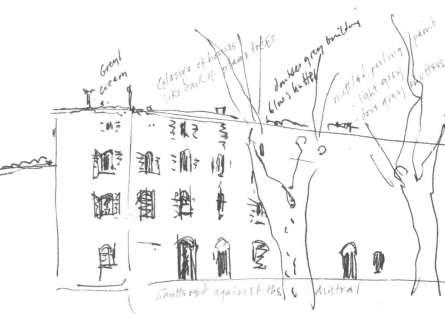

Great
cream

Colours of houses
like bark of plane trees

donkey grey building
blue shutter

mottled, peeling paint
light grey
dove grey shutters

Sheltered against the Mistral

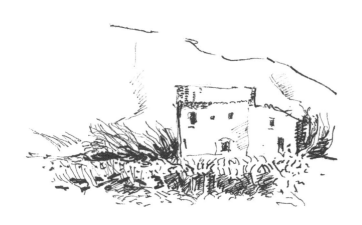

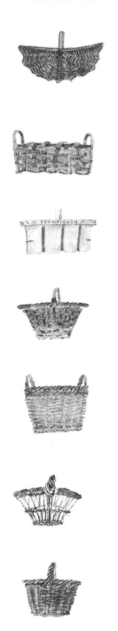

LE PAIN

Bread

la tête d'Aix

sablé
au chocolat

Le charleston niçois

La couronne

Pain aux olives

Son

La Fougasse

la baguette

BOULANGERIE

la main de Nice

la lune

le restaurant

Fougassettes - Anchois

Michettes à la tonne

l'épis

le Pain d'Aix

Grissini

les rioutes

119

THE DAILY BAGUETTE.

land of sun

and ripening

lemons

- "Au mois de Février, il faut bien se chauffer, bien boire et bien manger."
- The month the almond flowers - first sign of spring.
- 2nd February 1859: The epic Provençal poem 'Mireio', by Frédéric Mistral is published in Avignon by Joseph Roumanille.
- First fresh goat cheeses appear in the market.
- Muscari, grape hyacinth is in flower and growing wild.
- 3rd February 1888: Van Gogh is living in a room above the Restaurant Carrel - the 'Night Café of his paintings - in Arles. A year later he writes from Arles in a letter to his brother, Theo, "You may be old or young, but there will always be moments when you lose your head."
- Peach trees in blossom.
- 14th February: Opuntia cactus leaf - cuttings in the nursery - appropriate shape for today.
- First narcissus bulbocodium - (hooped petticoat) in flower.
- 16th February 1868: Georges Sand arrives at the Villa des Bruyères in Cannes
- Hear the first toads mating.
- 27th February 1926: Pierre Bonnard buys the house at Le Cannet he names "Le Bosquet" (The Grove) and describes as "property planted with orange trees, containing a two-storey house and two reservoirs fed by the waters of the Canal de la Siagne."
- Eat omelette aux oursins (sea urchins.)
- 28th February 1895: At five in the afternoon, Marcel Pagnol is born in Aubagne, while on same day in same town, Louis Lumière shows the first cinematic film.
- Pick first avocado and first lemon.
- The mistral wind is so cold. Houses seem built to keep cold in. Picnic in car - layer of ice round yolks of hard - boiled eggs.
- Stendhal writes the mistral is "... the great drawback to all the pleasures that one can find in Provence.... one does not know where to take refuge ..."
- Much weeding under olive trees. Dried olive pips amongst bulbs. Warmth on one's back.
- February 1938: In the Crau (stony area east of the Rhône), the mistral reaches speed of 250 km hr.

BUNCHES OF DAFFODILS

THIN IRISES

FREESIA

CARNATIONS — PINK, WHITE, VARIEGATED, YELLOW MOTTLED, STRIPED

AMARYLLIS BUDS

STRELITZIA PACKED IN CARS

4.30 a.m.

wholesale flower market.

A crush of flower laden people, bicycles, trucks and cars.

Pots of — TULIPS
MUSCARI
HYACINTHS

LUPINETTI

In bunches or boxes — LILIES
RANUNCULUS
EUCALYPTUS
GLADIOLI
FORSYTHIA
LILAC
PROTEA
CYMBIDIUM
VIOLETS
LILY-OF-THE VALLEY
NARCISSI
IRIS
AMARYLLIS BUDS

BUNDLES OF ALMOND BLOSSOM

Flowers in sprays, protected with cotton wool for —
'SAN VALENTINO CON AMORE'.

2 small buckets of wild flowers — daisies and Monk's cowl.

Stall selling almost everything connected with gardening.

CELLOPHANE BAGS
BAMBOO stakes, skewers, poles
ELASTIC BANDS, FLOWER WIRE, NYLON CORD
SECATEURS, GLOVES, SAWS AND CHAIN SAWS.

Breakfast - coffee and custard filled donuts.
Find Cesare the basket maker at his stall. follow him
to his workshop high above the town, surrounded by
greenhouses.
Stacks of wood, bamboo, shavings, and reeds. Benches
piled with baskets in various stages of construction.
Blue plastic ones on another bench.
Leave with his picnic basket - (to be
replaced by a blue one), of broadly woven split chestnut
wood and two bentwood handles.

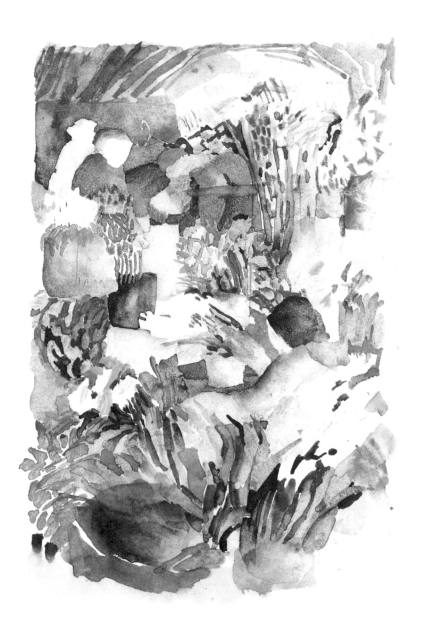

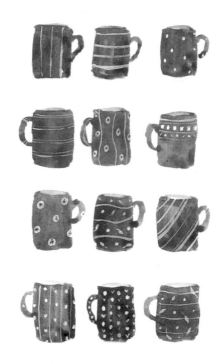

Ideas - using - green, yellow, black/aubergine, burnt sienna and white.

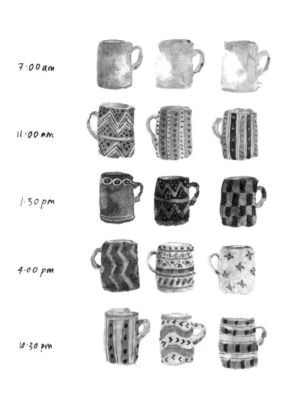

7·00 am

11·00 am

1·30 pm

4·00 pm

10·30 pm

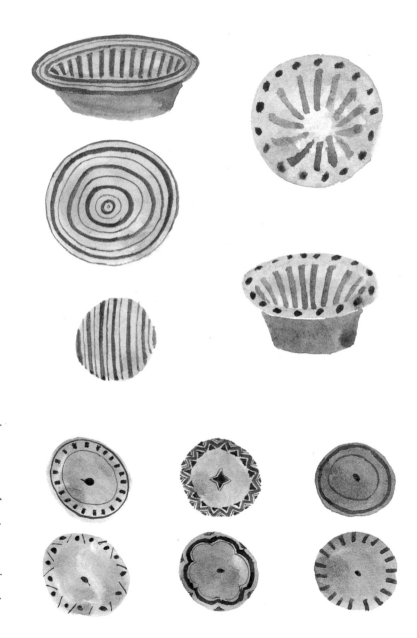

Surface patterns for plates, bowls, platters and dishes.

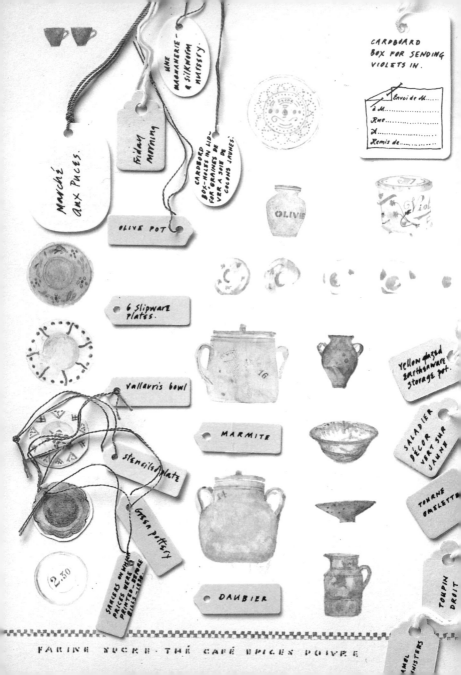

MARCHÉ AUX PUCES.

MME MAGNANERIE À SILKWORM NURSERY.

Friday morning

CARDBORD BOX-HOLES IN LID FOR "GRAINE DE VER À SOIE DE COCONS JAUNES".

CARDBOARD BOX FOR SENDING VIOLETS IN.

Envoi de M......
à M......
Rue......
à......
Remis de......

OLIVE

Viol

OLIVE POT

6 Slipware plates.

Yellow glazed earthenware storage pot.

Vallauris bowl

MARMITE

SALADIER DECOR VERT SUR JAUNE

stencilled plate

TOURNE OMELETTE

Green pottery

2.50

SAUCERS ON WHICH PRICES WERE PRINTED BEFORE SALE — 1950.

DAUBIER

TOUPIN DROIT

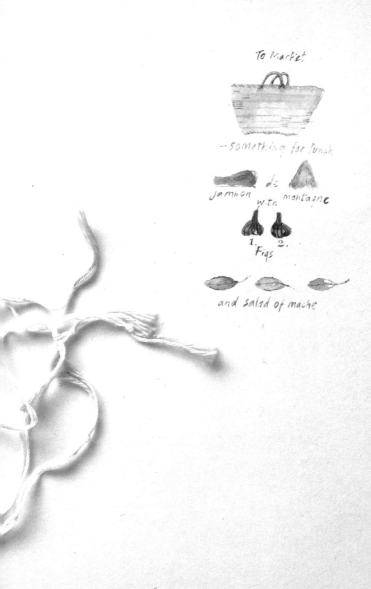

To Market

—something for lunch

Jambon de
 with montaigne
 1. 2.
 Figs

and salad of mache

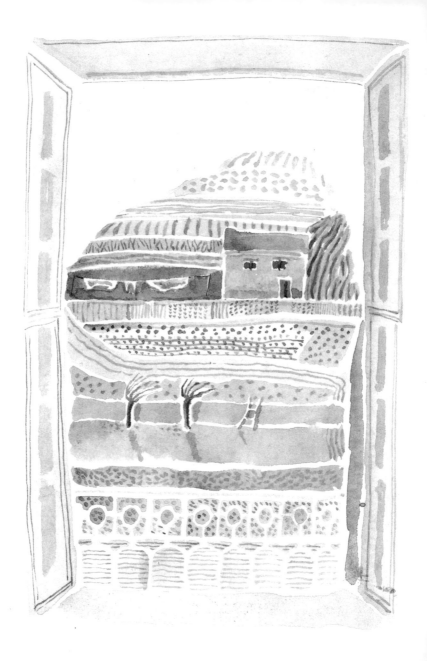

134

Gambusia fish sun themselves at the pond's surface, enjoying the
first warmth; soon there will be plenty of mosquitoes for them to eat.

- 1st March 1815: Napoléon lands at Golfe-Juan.
- When it thunders in March, the almond is good.
- 2nd March 1930: D. H. Lawrence dies in Vence.
- Toads spawn.
- 16th March 1898 - Aubrey Beardsley dies, and is
buried in Menton.
- 17th March 1955: Nicholas de Staël dies in Antibes.
- Cherry trees blossom.
- Wild asparagus appear. (delicious in omelettes).
- **The nightingale's song heralds the spring.**
- Hear first tree frog.
- 21st March: spring arrives two days later than the swallow.
- 23rd March 1953: Dufy dies in Forcalquier and is buried at Cimiez.
- 25th March 1914: Mistral, dies in Maillane, one hour after midday.
- 23rd and 24th March 1889: Paul Signac, en route to Cassis, visits
Van Gogh in hospital at Arles, and persuades the police to let him
return to the Yellow House. As a token of his gratitude Van Gogh gives
Signac a painting of two smoked herrings; this has an ironic
significance as the local nickname for gendarme is smoked herring.
- The turtle hauls herself out of the garden pond for first sunbathe
of the year.
- 27th March 1847: Emile Zola's father, François, builder of L'infernet
dam and the Aix canal, dies at Marseilles.
- Bantams lay their first egg - perfect to take, lightly boiled, on picnic.
- March 1863: Charles Gounod arrives at the Hôtel de la Ville Verte
in Saint Rémy to discuss with Mistral the possibility of
adapting 'Mireio' as an opera. He immerses himself in the
atmosphere on long walks with Mistral and speaks of the
landscape as "a marvel of savagery".
- Make peach-leaf wine.
- March 1883: Robert Louis Stevenson moves to Hyères, where
he writes part of 'A Child's Garden of Verse. He is here when
Treasure Island is published, and later says "I was only happy
once - that was at Hyères".
- Bats swoop over the pond to feed off insects.
- March 1897: Queen Victoria and Gladstone meet for the last time
at a hotel in Nice
- First hummingbird moth hovers over last hellebore flowers.

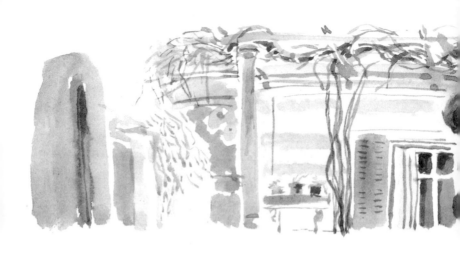

Jarre en terre cuite

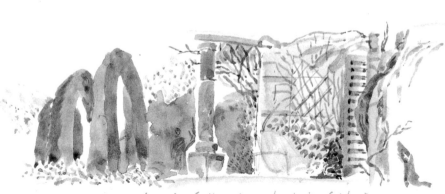

Façade ombragés d'une treille de glycine-(wistaria).

137

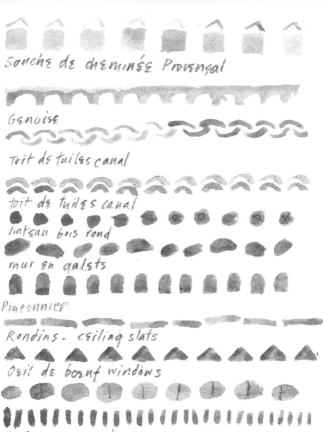

Souche de cheminée Provençal

Genoise

Toit de tuiles canal

Toit de tuiles canal

linteau bois rond

mur en galets

Pigeonnier

Rondins - ceiling slats

Oeil de boeuf windows

linteau en brique

mur en pierre sèche

colombier

Tiled roof - echoes the colour of the earth

Mur en plaquettes entassées (piled up.)

CLOARS

TERRACOTTA

TOMETTE

GLAZED TILES

PEBBLES

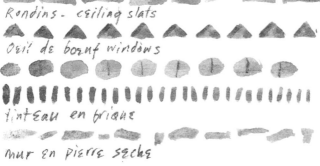

FRIEZES

BEDROOM CEILING · Painted clouds

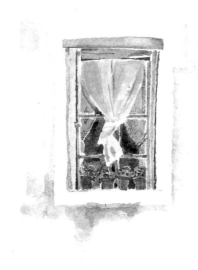

TROMPE L'OEIL →

Hand carved stone

BALCONIES —
wrought iron

Pigeonnier

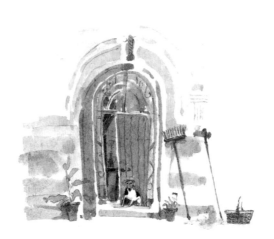

ATTENTION AU CHIEN

146

"PiTCHOUNETTE"

SAVON BONBONNIERE

"LES OPUNTIAS"

LA RONDERA

19

VISITEUR

MON RÊVE

MAISON RÉ

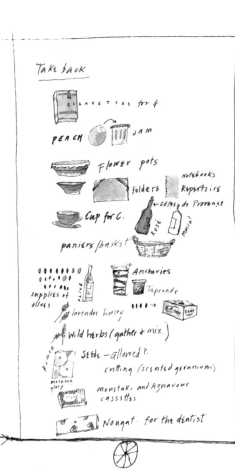

Take back

CIGARETTES for G

PEACH JAM

Flower pots

folders Notebooks
Repertoires

Cup for C. ← côtes de Provence
ROSÉ Muscat

paniers / basket

supplies of olives OLIVE Anchovies
Tapenade

SAVON SAVON

lavender honey

Wild herbs (gather & mix.)

SEEDS — allowed?
cutting (scented geranium)
morning glory

moustaki and Aznavour cassettes

Nougat - for the dentist

"The houses, all carefully shut against the heat, cast a narrow band of shadow. A mingled smell came from them of tomatoes, oil, soup and bread. But all sound was smothered by the massive walls and the closed shutters." BOSCO - 'Barboche.'

"At the age of 56, thanking an Aixois friend for some olives, he wrote gratefully: 'they brought me back a little of that South, so distant to-day, yet so living in my heart. Some fruit or drink or even smell will call it up with singular intensity." ZOLA by Joanna Richardson.

"The climate is so hot and dry in summer, that the plants must be watered every morning and evening. It is surprising to see how the productions of the earth are crowded together. One would imagine they would rob one another of nourishment;.... olive and other fruit trees, are planted in rows, very close to each other. These are connected by vines, and the interstices between the rows are filled with corn. The gardens that supply the town with salad and pot herbs lie all on the side of Provence by the highway. They are surrounded with stone walls or ditches, planted with a kind of cane or large reed, which answers many purposes in this country.— The leaves of it afford sustenance to the asses, and the canes not only serve as fences to the enclosures, but are used to prop the vines and peas, and build habitations for the silkworms. They are formed into arbors and wore as walking staves." SMOLLETT - 'Travels through France & Italy.'

"They were burning dry heather in the fire-places because it flames up hotter than slow wood. The smell that came up to our hill was filled with the gestures of women over the soup pot, with the sound that soup makes when it is on the point of boiling and is seething at the assault of a hot young fire." GIONO - 'Blue Boy.'

"You cannot put hens and roosters together without making eggs." GIONO

"I had a small room with a paper of rosebuds, an old bed like a rowing boat, an old walnut chest of drawers, a chair and a rickety table. The sheets smelt of soap and French lavender; the curtains were looped back at the window." BOSCO

"Oh those farm gardens, with their lovely big red Provençal roses, and the vines and fig trees. It is all a poem, and the eternal bright sunshine too, inspite of which the foliage remains very green. ... No cypresses or olive trees here." VAN GOGH.

... but that I would rather feel myself than feel alone. And I think I shall feel depressed if I did not feel myself that everything ... It is ... VAN GOGH.

"Lorsque le voyageur descend les pentes du Rhône, à un certain moment, sur la gauche, les montagnes s'écartent, l'horizon s'élargit, le ciel devient plus pur, la terre plus somptueuse, l'air plus doux; c'est la Provence." LACORDAIRE.

"The hills are shaded to the tops with olive trees, which are always green, and these hills are overtopped by more distant mountains, covered with snow. When I turn myself towards the sea, the view is bounded by the horizon, yet, on a clear morning, one can perceive the high lands of Corsica." SMOLLETT - 'Travels through France and Italy.'

"On the pink wall the spider stuffs itself with mosquitoes, the large green lizard haunts the chimney flu; the huntress snake polices the garden and leaves you its used skin as a bonus laced with grey balsamy ... under the lamp which will illuminate my threshold tonight I shall show you a group of toads waiting for night, the light, and the flying manna of the bombyx. ... Provençal evenings..."